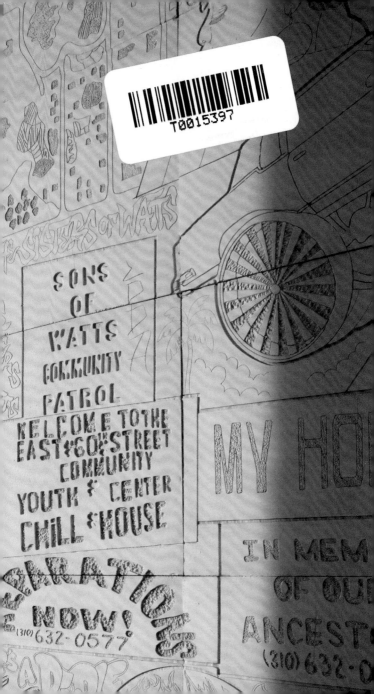

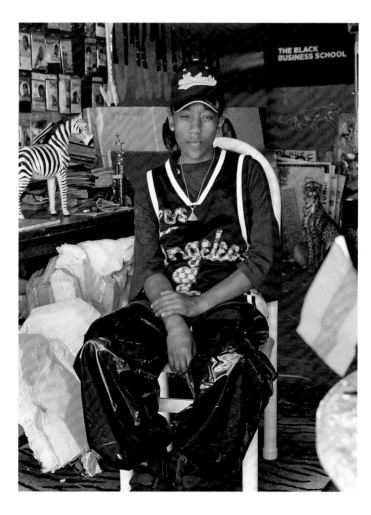

The Roof Garden Commission

# Lauren Halsey

Abraham Thomas

Douglas Kearney

The Metropolitan Museum of Art, New York

Distributed by Yale University Press
New Haven and London

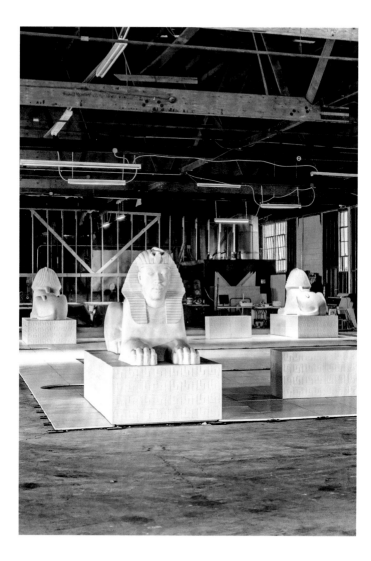

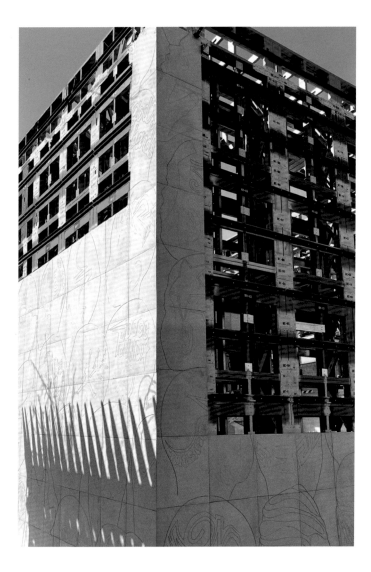

# Sponsor's Statement

Bloomberg Philanthropies is proud to partner with The Metropolitan Museum of Art in support of *The Roof Garden Commission: Lauren Halsey*. For more than a decade, we've sponsored exceptional contemporary art exhibitions on The Iris and B. Gerald Cantor Roof Garden, and Halsey's site-specific installation continues this tradition. The artist draws on influences such as ancient Egyptian hieroglyphs, 1960s utopian design, Afrofuturism, and imagery from her South Central Los Angeles neighborhood to explore communities and their built environments.

Bloomberg Philanthropies works in 700 cities and 150 countries around the world to ensure better, longer lives for the greatest number of people. The foundation focuses on five key areas for creating lasting change: arts, education, the environment, government innovation, and public health. The arts are an invaluable way to engage citizens and strengthen communities. Through innovative partnerships and bold approaches, the Bloomberg Philanthropies arts program supports increased access to culture through new technologies and empowers artists and cultural organizations to enhance the quality of life in cities.

**Bloomberg
Philanthropies**

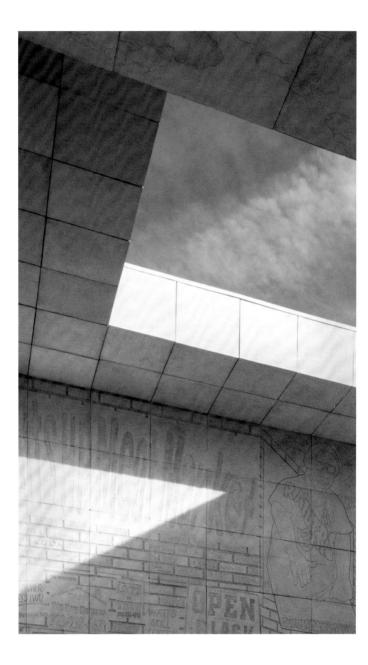

# Director's Foreword

Situated atop The Met and surrounded by the Manhattan skyline, The Iris and B. Gerald Cantor Roof Garden has provided unparalleled inspiration to artists invited to create site-specific commissions for this setting.

This year, we are delighted to present a compelling architectural project by Lauren Halsey. Inspired by Afrofuturism and funk music, Halsey draws on the signs and symbols that populate the built environments of her local neighborhood in South Central Los Angeles. Featuring contemporary hieroglyphic narratives wrapped around structures that borrow equally from ancient Egyptian forms and 1960s utopian designs, her commission invites us to reconsider how architecture and community engagement can manifest in our civic spaces.

Initiated by Sheena Wagstaff, former Leonard A. Lauder Chair, Department of Modern and Contemporary Art, and organized by Abraham Thomas, Daniel Brodsky Curator of Modern Architecture, Design, and Decorative Arts, Halsey's work joins a distinguished group of annual commissions for this site.

For its long-standing and generous sponsorship of this commission series, I thank Bloomberg Philanthropies. I am also grateful to The Daniel and Estrellita Brodsky Foundation, to the Barrie A. and Deedee Wigmore Foundation, and to Cynthia Hazen Polsky and Leon B. Polsky for their leadership support. Additionally, my thanks are owed to Vivian and Jim Zelter and Carla Emil and Rich Silverstein for their own wonderful gifts to this exhibition. This catalogue is made possible by the Mary and Louis S. Myers Foundation Endowment Fund.

Max Hollein
Marina Kellen French Director
The Metropolitan Museum of Art

# South Central Dream Worlds

Abraham Thomas

Strolling along the southeastern edge of the Great Lawn in Central Park, you might glance up and encounter the obelisk of Thutmose III (popularly known as Cleopatra's Needle), a diplomatic gift from the Egyptian government that was transported to New York in the late nineteenth century. Built in 1425 B.C., the towering object features hieroglyphic markings that can still be read up close. As you squint to study these details, you may also discern out of the corner of your eye a set of similar carvings that adorn another monumental (but more short-term) transplant to this area of the park. Titled *the eastside of south central los angeles hieroglyph prototype architecture (I)* and perched atop The Met, this contemporary cube-like structure is artist Lauren Halsey's contribution to the Museum's ongoing Roof Garden Commission series. Almost every surface of her installation, including the surrounding columns, is covered with a dense collage of phrases and images—all drawn from a specific vernacular of signs, texts, and symbols observed in the artist's historically Black neighborhood of South Central Los Angeles—that together result in an architectural container of community archives and histories. Legible at different scales from both the park and The Met's Iris and B. Gerald Cantor Roof Garden itself, Halsey's building is at once structure, poem, drawing, and collage.

Halsey's interest in the material culture of ancient Egypt has long been a thread throughout her work. Early exposure came via her father's interests in the funk pioneer George Clinton and his Parliament-Funkadelic ensemble, and the avant-garde jazz composer Sun Ra and his Arkestra. Known for their conjured images of ancient Egypt as part of sonic manifestos around Black pride, power, and imagination, both groups used the tools of Afrofuturism to reclaim certain histories and lost legacies. By incorporating spirituality and transcendence into their musical explorations of fantastical futures, Clinton and Sun Ra created narratives that centered the Black experience and espoused a radical philosophy that was inspirational and emancipatory. Halsey also recalls how, as a young girl sitting in her bedroom, she would listen to in-depth conversations taking place between her father and his friends in the backyard during halftime breaks of football games, in which they would discuss a "very idiosyncratic form of freestyling origin stories and bloodlines"[1]—topics that stemmed from her father's deep interest in ancient Egyptian history.

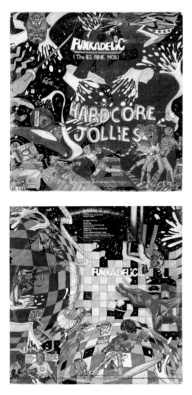

Fig. 1. Double-gatefold album cover for *Hardcore Jollies* by **Funkadelic**, 1976. Afrika Bambaataa Vinyl Collection, Cornell University Hip Hop Collection, Division of Rare and Manuscript Collections, Cornell University Library

The world of Parliament-Funkadelic offered Halsey an introduction to the idea of speculative imagination, something that empowered her to construct various alternative realities, histories, and futures within her mind. The maximalism of the group's sonic cues, lyrics, and multilayered musical textures allowed her to experience "dreamlike, fantastical, future past spaces . . . where I was able, during a very difficult childhood, to experience myself in a way that just felt emancipatory . . . like all I have to do is be a pharaoh in my head, or all I have to do is be an Afronaut."[2]

On a purely visual level, Funkadelic's madcap album cover designs of the 1970s also appear to be a key reference point for Halsey. For example, the double-gatefold sleeve for *Hardcore Jollies* (1976) (fig. 1)—with its dense, trippy, hyper-colored narratives that seem to borrow equally from cartoonist Robert Crumb and the photomontages of John Heartfield—offers an intriguing correlation with Halsey's digital and mixed-media collages. (figs. 2–4).

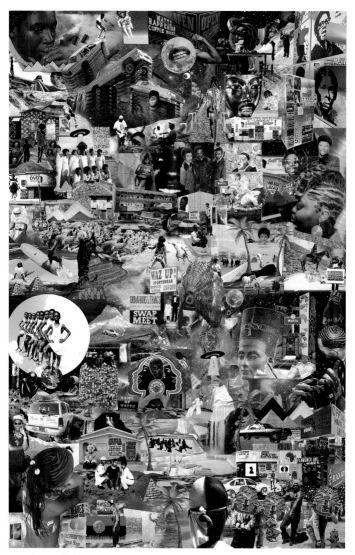

Fig. 2. **Lauren Halsey.** *Watts Happening*, 2021. Inkjet print on paper, 96 × 62 ½ in. (243.8 × 158.8 cm), 2 A.P., edition of 6. Collection of the artist. Courtesy of David Kordansky Gallery

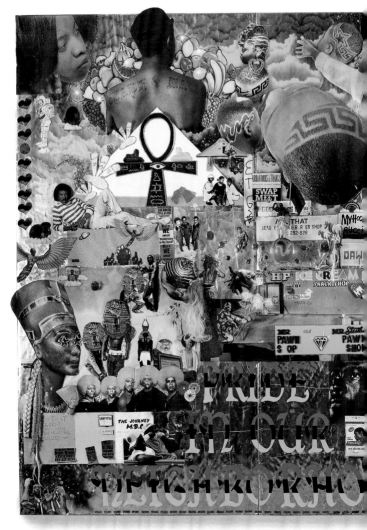

Fig. 3. **Lauren Halsey.** *LODA,* 2022. Mixed media on foil-insulated foam and wood, 97 1/2 × 152 × 20 in. (247.7 × 386.1 × 50.8 cm). Courtesy of David Kordansky Gallery

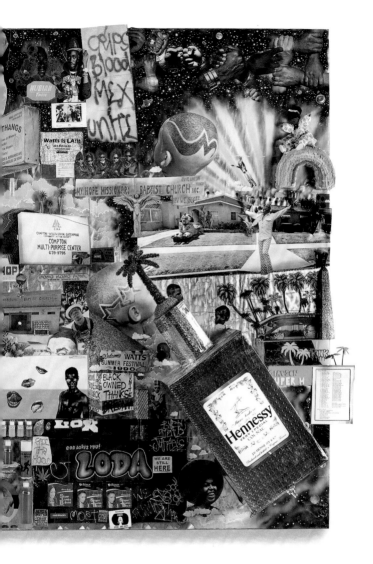

15

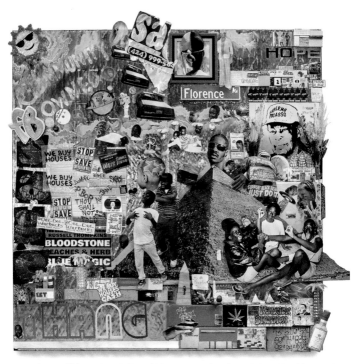

Fig. 4. **Lauren Halsey.** *thou shall not fold,* 2022. Mixed media on foil-insulated foam and wood, 102 ½ × 106 × 12 in. (260.4 × 269.2 × 30.5 cm). Courtesy of David Kordansky Gallery

These dizzying montage visions of society and architecture convey Halsey's interest in both documenting her community of South Central and creating an imaginary space of optimism for the future. Her mash-ups of hand-painted commercial signs, swap-meet notices, graffiti tags, remixes of ancient Egyptian sources, house purchase ads, community center murals, and activist slogans all combine in a pulsating dynamic that reflects the richness of her neighborhood but also articulates a state of precarious flux, caused by rapid gentrification and economic displacement. As Halsey puts it, the "fullness of the composition represents the fullness of community."

Another significant family influence was Halsey's grandmother, who would sometimes take the artist to services at a local spiritual center (fig. 5) that developed its devotional practice partly from Kemeticism, a revival of ancient Egyptian religion centered around the tenets of truth, balance, order, harmony, law, morality, and justice. Although Halsey personally adheres to a different theology

than that of her family's church, she acknowledges the impact of being immersed in the visual language of ancient Egypt, and the potential power of those structures (both the physical building of the center and its philosophical constructs) in defining the future of communities around her.

In 2007 while attending the architecture program at El Camino College in Torrance, California, Halsey took her first classes in Photoshop and began making digital collages. She describes these significant early works as "a meditative portal to get lost in. I would kick it with my best friends on my street while I was making them. They would be freestyling, I'd be making collages, and we would talk about our dreams, whatever our goals were at the time. I would come back to [the collages] later that night and zone out to Parliament-Funkadelic, watch Sun Ra in the background, and think up these trippy, Technicolor remixes of South Central."[3]

Halsey recalls that, when first developing these digital collages, she had in mind the striking designs of the 1960s avant-garde British architectural group Archigram (fig. 6). Their utopian proposals, such as *A Walking City*, *Plug-In City*, and *Instant City*, offered similar reflections on what urban design could offer communities, especially those needing to responsively adapt to constant change. Like the emancipatory visions detailed in Halsey's works, these were projects predicated upon the idea of architecture that could react to people's shifting needs and desires, rather than the creation of static monuments.

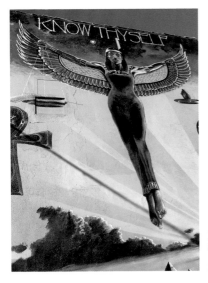

Fig. 5. View of a wall mural at a local spiritual center in South Central Los Angeles, 2021

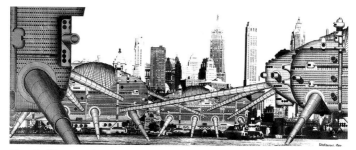

Fig. 6. **Archigram** and **Ron Herron**. *A Walking City*, 1964. Drawing, collage, 9 ¼ × 20 ⅞ in. (23.5 × 53.1 cm). Ron Herron Archive

According to Halsey: "Their proposals for architecture were so wild, so conceptually and structurally ambitious, that they can only exist as drawings. . . . Structures were living organisms, . . . where you would change contexts constantly. They beamed people up into architecture. [It was] a sort of Parliament-Funkadelic thing, without the cosmos. Their proposals for architecture were very inclusive for me because of their radical experimentation and approach to scale. It included me, you, every single person in the world, and in a way that was thoughtful and beautiful."[4]

This theme of maximalism runs throughout much of Halsey's work and within her design sources, and is something that she associates with her interests in the world of Pharaonic Egypt.[5] Halsey is specifically drawn to a prevalent hieroglyphic inscription known as the offering formula. Often inscribed on funerary architecture and other objects, these texts allowed the deceased to partake in offerings provided by the king (fig. 7). Halsey finds particular inspiration in the sheer sense of abundance depicted in these compositions, which appear almost like Surrealist still-life assemblages.

While attending the MFA program at the Yale School of Art, Halsey began work on a series of installations titled *Kingdom Splurge* (2013–14) (fig. 8). Explosions of textures, colors, and sculptural forms, these works represent the artist's early efforts to translate two-dimensional digital collages into a type of three-dimensional architectural space that conveys a comparable sense of material accumulation and rhythmic energy.

Peppered throughout the *Kingdom Splurge* installations are objects that Halsey acquired during visits back to Los Angeles or that were given to her by her grandmother, who made trips to the artist's favorite mom-and-pop shops and local street vendors on her behalf. Whenever Halsey traveled to the city during breaks from school, she

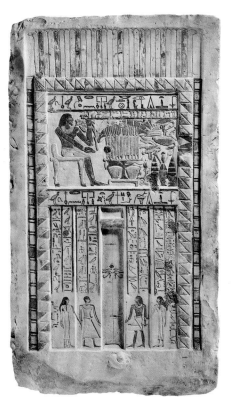

Fig. 7. False Door of the Royal Sealer Neferiu. Egypt, Old Kingdom–First Intermediate Period, ca. 2150–2010 B.C. Painted limestone, H. 45 ½ in. (115.5 cm). The Metropolitan Museum of Art, New York, Gift of J. Pierpont Morgan, 1912 (12.183.8)

would notice that "certain spaces, voices, and textures were disappearing. I felt an urgency to archive them because they were gorgeous and incredibly important to me." These materials were a way for Halsey to remain connected to Los Angeles and to source and accumulate "a tangible archive to assemble new forms . . . [such as] my ideal city blocks, and fantasy geographies [that were combined] with elements of real nature that I discovered looking through copies of *National Geographic* at my grandmother's home."[6]

The *Kingdom Splurge* installations also reveal Halsey's long-standing interest in the depictions of material excess and accumulation found on ancient Egyptian funerary objects. The dreamlike internal worlds in Halsey's installations offer an interesting parallel

Fig. 8. **Lauren Halsey.** *kingdom splurge (1.10.7.13)*, 2013. Mixed media. Installation view, Yale School of Art, New Haven

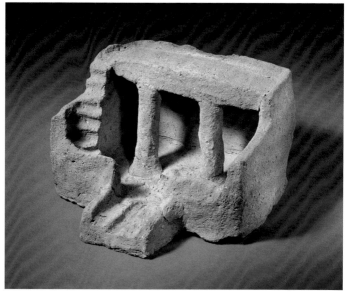

Fig. 9. Model of a house (so-called soul house). Egypt, Middle Kingdom, mid–Dynasty 13, ca. 1750–1700 B.C. Pottery, H. 6 ¾ in. (17 cm). From Deir Rifa, Tomb 72, British School of Archaeology in Egypt Excavations 1906–7. The Metropolitan Museum of Art, New York, Gift of The Egyptian Research Account and British School of Archaeology in Egypt, 1907 (07.231.11)

to the purposeful arrangement of items accompanying ancient people during their passages to the afterlife. Particularly, the miniature shop fronts forming a backdrop streetscape in *Kingdom Splurge* echo the carefully preserved architectural models known as "soul houses" that have been discovered within various Egyptian burial sites and tombs (fig. 9). Scholars still know very little about these ancient objects, but they were possibly intended to "archive" actual built structures or to act as libation basins during offering rituals.

The idea of the architectural model as a speculative tool for future visions is an important counterpart to Halsey's use of collage as a process to explore alternative possibilities. She cites the 1960s architectural models of André Bloc's "sculptures habitacles" (cubicles) as being a specific influence, notably in the ways they articulate organic forms and negotiate the delicate balance of external light and internal space (fig. 10).

Halsey's interest in architecture stems from a position of activism and resistance, one that evolved from a childhood profoundly impacted by the oppressive architecture and infrastructure that surrounded her in South Central. Attending a school that was well outside

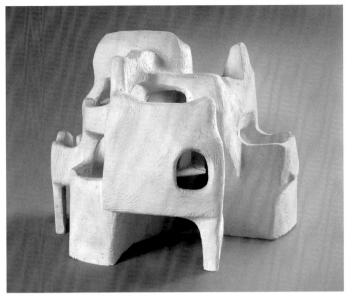

Fig 10. **André Bloc.** "Habitacle" architectural model, ca. 1962. Plaster, 17 ⅞ × 23 ½ × 20 ¼ in. (45.5 × 59.5 × 51.5 cm). Centre Pompidou, Paris, Don de Mme André Bloc, 1980 (AM 1980–483)

her neighborhood, Halsey would often feel anxious going back home every day. Returning from socializing with friends in other areas of the city, she would observe the stark differences in certain architectural details such as building cladding and facade textures, in addition to the ubiquity of certain hard measures such as barbed wire and security bars. Part of what motivated her to study architecture at El Camino was the opportunity to collaborate with friends, to "just go build something, and it would be a space of pleasure . . . a sort of spiritual space where we could feel free."[7]

Halsey's overarching artistic vision is to draw upon the various templates, propositions, and ideas in her collages and installations in order to create a permanent building in her neighborhood, which would act as a resource to the community. She calls this proposed structure "survival architecture," which would serve as an act of resistance against the oppressive forces of corporate development, displacement, and rampant gentrification that have come to dominate areas of South Central—for example, the construction of SoFi Stadium for the Los Angeles Rams football team in the heart of Inglewood or the increasing expansion of the University of Southern California campus into

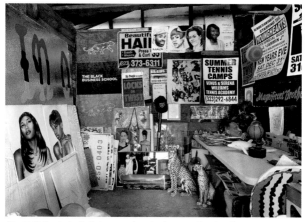

Fig. 11. Halsey's studio in her grandmother's garage, Los Angeles, 2019

southern parts of the city. Halsey describes her neighborhood as being composed of "a resilient architecture built by our hands that holds our stories, our ephemera and objects, our art, our scents, our specific cultural histories, etc. We've been consistently under attack for centuries. Now we're fighting, as we always have, for space and the future of our neighborhoods. How do we refuse to be displaced, assert our autonomy, and survive? Most of my interest in architecture is in its potential to elevate the collective experience of a neighborhood. I can't think about Black transcendence within South Central without thinking of our built environment and architecture first."[8]

During her time at El Camino, Halsey established a makeshift studio in her grandmother's garage, which soon became a base for collecting and archiving signs, objects, and other materials from her neighborhood (fig. 11). Later, while completing her bachelor's degree at the California Institute of the Arts (CalArts) in 2012, Halsey embarked on a series of works that she termed "bus drawings," which she created during her lengthy twice-daily commutes to and from school. By compiling meticulous observations made through the window and utilizing snatched pieces of conversations heard while aboard, Halsey took advantage of the tedious repetition and constant stop-starting on these bus routes to document the graphic language, visual grammar, and architectural landscape of her neighborhood. As she put it, "I wanted everybody's hand in the archive I was accumulating."[9]

Halsey borrowed from the frenetic cut-and-paste aesthetic of Funkadelic's album cover designs for some of her drawings, but for others she took a more indexical, yet equally poetic, approach to cap-

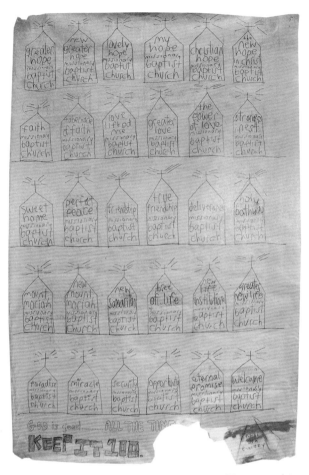

Fig. 12. **Lauren Halsey.** *the voices of greater love,* 2010. Graphite on newsprint

turing the vernacular architecture that populated her community. For example, one drawing carefully lays out, via an objective grid of identical abstract building facades, a series of signs with evocative local Missionary Baptist church names such as "Perfect Peace," "Love Lifted Me," or "Greater New Life" (fig. 12). Halsey states that she "fell in love with the promise of the titles [while also] existing in such contradiction to the promise of these titles."[10] This archive of bus drawings provided the core DNA for what would later become her digital collages and also offered the organizational framework for the graphic signs, markings,

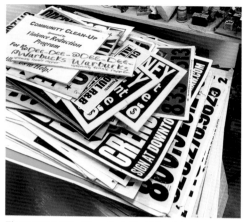

Fig. 13. Community signs collected by Halsey in her Los Angeles studio, 2021

words, and images on the complex panel carvings within her Roof Garden Commission.

Halsey believes in the power of repetition, whether that's with words and phrases or with visual motifs. There are certain texts and image patterns that she repeats over and over again, almost like a mantra, to convey resilience and to declare: *we are here, we will be here.*[11] The artist describes her "sampling and remixing" as a way to "constantly recontextualiz[e], to sort of stretch the meaning of what an image, or figure, or text can be."[12]

Halsey first started documenting and collecting signs in South Central (fig. 13) because she had "always been obsessed with local graphics and stylistic details like penmanship, color, fonts ... That turned into documenting specific names of churches and businesses, ... and being pretty obsessed with grammar. . . . A lot of it had to do with color and the freedom to experience Los Angeles, scale, outer space, car culture, church signs, ice cream, [and] my neighborhood's architecture in a way that was complicated and beautiful."[13]

A similar approach to studying the architectural vernacular of commercial signage and typography can be found in Robert Venturi and Denise Scott Brown's pioneering publication *Learning from Las Vegas* (1972) (fig. 14) and the subsequent exhibition *Signs of Life: Symbols in the American City* (1976). Begun in 1968 after the two architects Venturi and Scott Brown traveled to Las Vegas with their graduate students at Yale's School of Architecture, the research project docu-

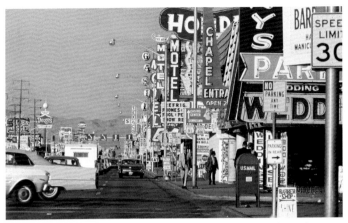

Fig. 14. **Denise Scott Brown.** *Architettura Minore on The Strip, Las Vegas* (research photograph for the *Learning from Las Vegas* project), 1966. Giclée pigment print, sheet: 11 × 17 in. (27.9 × 43.2 cm). Carnegie Museum of Art, Purchased with funds provided by Elise Jaffe + Jeffrey Brown (2019.16.3)

ments the taxonomy of street symbols created by the Las Vegas Strip and the vivid signs of the casinos and "decorated sheds" along it.[14] The hectic energy of the colorful neon signs in Scott Brown's photographs is echoed in Halsey's dynamic collages and Day-Glo-infused installations (figs. 15, 16). Venturi and Scott Brown compiled much of their research for *Learning from Las Vegas* from a moving car, thus developing a specific way of observing the city along a linear path and noting its various repetitions and contradictions—rather like Halsey, who created her early drawings along the prescribed bus routes of Los Angeles.

Beyond the bus drawings themselves, Halsey speaks eloquently about how traveling by bus (something she has done for most of her life) has defined the way she experiences and navigates the city and its people: "Taking the Crenshaw bus, there were all these boulevards and avenues with huge egos and attitudes and personalities and stories and hustlers and performers. I loved it. The bus taught me to see things very slowly. Especially doing it every single day. Also, it taught me to really appreciate what people produce, because there are so many people on the bus who are selling something . . . [The experience allowed me] to spend time with people and their stories and their histories and to dig deeper and create relationships with them."[15]

For the last few years, Halsey has been working toward translating her collaged visions and immersive installations into freestanding structures that can be experienced by the public as full-scale examples of architecture. For her pivotal residency at The

Fig. 15. **Lauren Halsey.** *South Central El Aye Hieroglyphic Fubu Architecture (Rendering I),* 2015. Digital collage, dimensions variable. Collection of the artist

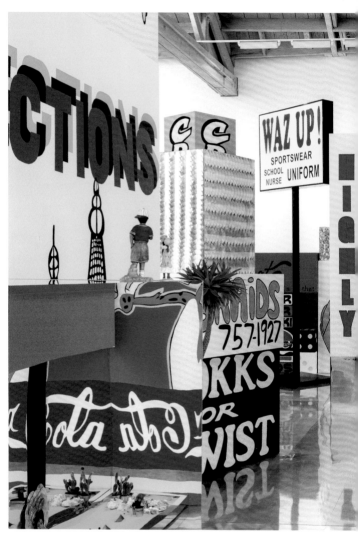

Fig. 16. Installation view of *Lauren Halsey*, David Kordansky Gallery, Los Angeles, 2020

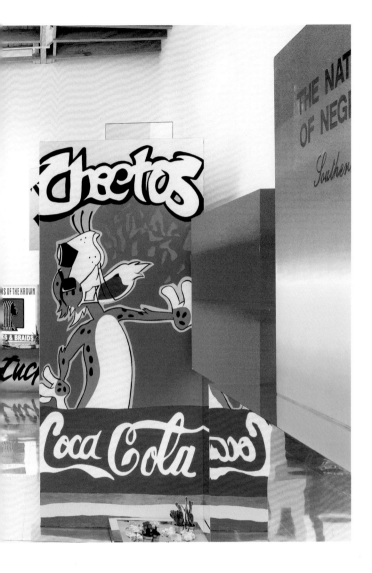

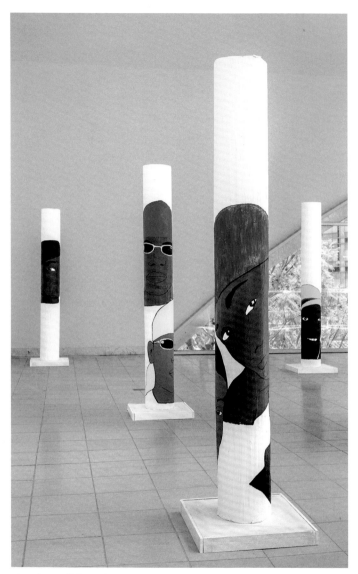

Fig. 17. **Lauren Halsey.** *The Crenshaw District Hieroglyph Project (Prototype Architecture),* 2018. Gypsum, wood, tape, and acrylic. Installation view, Hammer Museum, Los Angeles

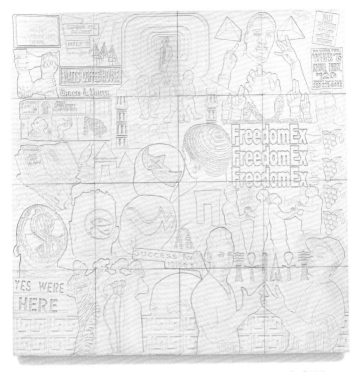

Fig. 18. **Lauren Halsey.** *FreedomEx*, 2022. Gypsum on wood, 94 × 94 1/8 × 5/8 in. (238.8 × 239.1 × 1.6 cm). The Metropolitan Museum of Art, New York, Purchase, Lila Acheson Wallace Gift, 2022 (2022.359)

Studio Museum in Harlem in 2015 and 2018 installation at the Hammer Museum in Los Angeles (fig. 17), Halsey transferred the texts and images from her community archive onto intricately carved gypsum panels. These compositions, with their combination of sharply incised details and sculptural raised reliefs, reclaim the visual grammar of the hieroglyph and act as a tool for archiving, documenting, and commemorating the people and places that populate Halsey's community (fig. 18). The structures on which these panels might be placed are not intended as memorials but instead are living examples of architecture that will continue to evolve—eventually representing a complex, contradictory, and ever-shifting series of neighborhoods.[16]

Halsey describes gypsum (the main component of drywall, or Sheetrock) as her "superstar material" because of its accessibility

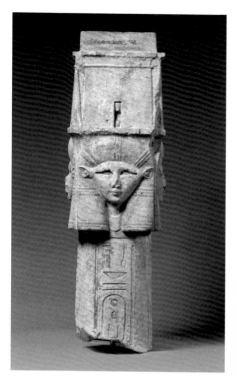

Fig. 19. Column with Hathor-Emblem Capital. Egypt, Late Period, Dynasty 30, reign of Nectanebo I, 380–362 B.C. Painted limestone, H. 40 3/16 in. (102 cm). The Metropolitan Museum of Art, New York, Gift of Edward S. Harkness, 1928 (28.9.7)

and ubiquity, recalling childhood memories of shopping at Home Depot with her father to collect panels of Sheetrock for various DIY projects.[17] For the interior and exterior surfaces of her Roof Garden structure, she chose glass-fiber reinforced concrete, a material that would have a similar look to Sheetrock. The walls are embedded with a series of interconnected narratives and visual motifs from her South Central neighborhood, documenting everything from local hair salons, body-builder gyms, and lowrider car clubs to vital cultural centers in danger of demolition, such as the Mafundi Institute in the Watts neighborhood, and statements of resistance and presence. Examples of text include *Yes We're Open Yes We're Black Owned*; *Build Autonomy*; *Magnificent Sisters & Magnificent Brothers*; and *Black Workers Rising*. Surrounding this structure are a series of sphinxlike forms and columns, which take their cue from the Hathor columns of Late Period Egypt (ca. 664–332 B.C.) (fig. 19). In her work, Halsey has replaced representations of the cosmic goddess Hathor that traditionally adorned the capitals with those of important members of her community—including local artists Pasacio

"the King" DaVinci and Barrington Darius—who act as protectors of the space on The Met's roof. The sphinxes represent key figures in Halsey's life, such as her mother, Glenda, and her partner, Monique. Each column and sphinx operates as an architectural-portrait-biography of sorts, offering a portal into the work of a specific local leader or close family member who Halsey believes is integral in defining the neighborhood's recent past, present, and immediate future.

Halsey blends elements of ancient Egyptian imagery with the formal gridline aesthetics of 1960s experimental architects Superstudio. This pioneering group is perhaps best known for its theoretical, iconic project *The Continuous Monument*, which proposed a single piece of architecture that would stretch itself over the entire surface of the world to "realize [the] cosmic order on Earth" (fig. 20). With its evocation of the infinite and the unbounded, this vision recalls not only the mythological worlds of Parliament-Funkadelic's lyrics but also Halsey's own reflections on the allure of her home city: "the spread of LA . . . the weather, it allows you to sort of feel like you could literally build to the sky."[18]

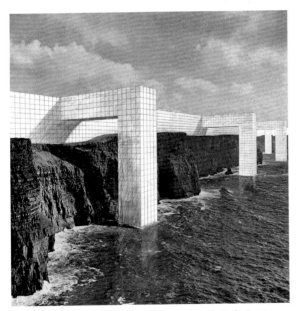

Fig. 20. **Superstudio.** *The Continuous Monument: On the Rocky Coast, Project (Perspective)*, 1969. Cut-and-pasted printed paper, colored pencil, and oil stick on board, 18 3/8 × 18 1/8 in. (46.7 × 46 cm). The Museum of Modern Art, New York, Gift of The Howard Gilman Foundation (1311.2000)

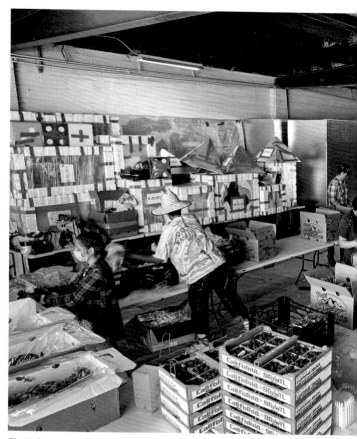

Fig. 21. Summaeverythang community center, Los Angeles, 2021

Her building for the Roof Garden exists as the most fully realized version of these spatial ideas to date, and her plan is to reassemble The Met installation back in South Central on a vacant lot just a few minutes' walk from her studio. In this way, the structure at the Museum is a prototype for a larger collaborative architectural project—one that will offer the resources of a community center while also being a place for shared authorship, community organizing, and civic advocacy.[19]

Halsey is adamant about the fact that her work cannot simply reference South Central and be purely representational or even performative. She feels that if the work exists outside her home and her studio, then there must be some sort of activation for community build-

ing in a way that offers and distributes resources "24/7/365 in real time and at no cost" with a result that has to be tangible.[20] In 2019, Halsey founded the Summaeverythang community center as an extension of her art practice, and as a literal physical extension to her studio (fig. 21). Although Summaeverythang was initially planned to offer a variety of community activities, including after-school programs and one-on-one tutoring, art and dance programs, music studios, and residencies, the COVID-19 pandemic and associated restrictions on group gatherings forced Halsey to swiftly pivot and repurpose the community center as a resource that distributed weekly organic food boxes, in addition to hygiene kits and art kits. She hopes that once activities can be expanded

to a broader series of community programs, she'll be able to offer training schemes and apprenticeships directly connected with the ongoing work of her studio.

Halsey has a long-term strategy to recycle dollars back into her Los Angeles neighborhood and to redistribute land, housing, and grocery stores via various community land-trust models she has been studying—in addition to building permanent examples of the kind of architecture that she has articulated through her collages, drawings, and installations for the past decade. Halsey notes that, at the time she was creating her bus drawings exactly ten years ago, there were several empty lots in her neighborhood (many of which are now filled with apartment buildings) and that she would use these drawings to conjure up imagined spaces and to superimpose these visions onto these tantalizingly open areas—almost "drawing into" the vacancies. In a few short years, we may well see the physical manifestation of some of these superimposed visions, once projected from the window of a Los Angeles bus.

As both a continuation of The Met's galleries and a site visible from Central Park, the Roof Garden has always existed as a strange extension of public space for a diverse mix of museum visitors, parkgoers, and Upper Manhattanites alike. It is only fitting that it now hosts a prototype redefining and "remixing" community-oriented architecture, which will, hopefully soon, be integrated into another vibrant landscape: that of South Central Los Angeles. As Halsey puts it: "I'm just so grateful that it will . . . become like a living structure . . . one that is in the neighborhood, of the neighborhood, for the neighborhood, and dedicated to the neighborhood."[21]

1. Lauren Halsey, interviews and conversations with the author, December 2021.
2. Ibid. "Afronaut" refers to a quote from George Clinton's sci-fi alter ego, Starchild, who describes "certified Afronauts, capable of funk-itizing galaxies."
3. Lanka Tattersall, "Lauren Halsey: The Future Is Now," in *Lauren Halsey: we still here, there*, exh. brochure (Los Angeles: The Museum of Contemporary Art, 2018), p. 2.
4. Tattersall, "Lauren Halsey: The Future Is Now," pp. 6–7.
5. This time span began with the Early Dynastic Period, starting about 3100 B.C., and ended in 332 B.C., at the conclusion of the Late Period.
6. Tattersall, "Lauren Halsey: The Future Is Now," pp. 3–6.
7. Lauren Halsey, interviews and conversations with the author, December 2021.
8. Tattersall, "Lauren Halsey: The Future Is Now," p. 6.
9. Tattersall, "Lauren Halsey: The Future Is Now," p. 2.
10. Lauren Halsey, interviews and conversations with the author, December 2021.
11. See Douglas Kearney, "The Next Chamber," in *Lauren Halsey: Mohn Award 2018* (Los Angeles: Hammer Museum, University of California; New York: Delmonico/Prestel, 2020), pp. 64–66.
12. Lauren Halsey, interviews and conversations with the author, December 2021.
13. Tattersall, "Lauren Halsey: The Future Is Now," p. 2.
14. See Robert Venturi, Denise Scott Brown, and Steven Izenour, *Learning from Las Vegas* (Cambridge, Mass.: MIT Press, 1972). Here, Venturi and Scott Brown coined the term "decorated shed" to describe the condition of generic functional buildings that relied heavily on expressive signs and bold ornamentation to distinguish themselves from one another, as was prevalent during the development of the Las Vegas strip and its abundance of neon signs.
15. Erin Christovale, "The Sum of Everything," in *Lauren Halsey: Mohn Award 2018* (Los Angeles: Hammer Museum, University of California; New York: Delmonico/Prestel, 2020), p. 139.
16. For more on the idea of cities as complex spatial containers defined by the shifting programs of everyday life, see Robert Venturi, *Complexity and Contradiction in Architecture* (New York: The Museum of Modern Art, 1966).
17. Mabel O. Wilson, "Social Works: Lauren Halsey and Mabel O. Wilson," *Gagosian Quarterly* (Summer 2021), pp. 51–52.
18. Lauren Halsey, interviews and conversations with the author, December 2021.
19. Alice Grandoit-Šutka and Isabel Flower, "The Art of Community," *Deem* (Winter/Spring 2021), p. 15.
20. See Anne Ellegood, "Lauren Halsey's Holding Environment," in *Lauren Halsey: Mohn Award 2018* (Los Angeles: Hammer Museum, University of California; New York: Delmonico/Prestel, 2020), pp. 116–20.
21. Lauren Halsey, interviews and conversations with the author, December 2021.

# A Conversation with
# Lauren Halsey

Douglas Kearney

**Douglas Kearney** What is it that draws you to architecture as a discipline?

**Lauren Halsey** Architecture is this amazing portal in which we—myself, in collaboration with my friends, my partner, my family, a cast of folks—can co-opt anti-Black spaces, allowing us to feel transcendent, inspired, energized, without having to consider the oppressive forces or the paradigms that surround us. We're building new, tangible space. So, these structures also feel very protective. Up until this point, I've been making these to-scale models that are experimental, but this will be the first opportunity for my studio to produce an actual architecture that can exist on a city block, which has been my goal since beginning to take architecture courses at a local community college in 2006. I see the Roof Garden Commission as an opportunity to hold space [for the Black community] and think about our maximalism, which will not only be represented on the walls of the structure but actually performed throughout the installation by it being this sort of everything space. A cultural center could be created within the cube. The space could transform into being about eating. The installation could be about being in community as far as conversation or performance. The commission can be this container for the very full and poetic Black experience, without the cladding that, as far as the style of buildings in South Central Los Angeles goes, represents angst and anxiety. These materials communicate, or are symbols of, how we're perceived. All that stuff goes out the window with our installation. So, I see the commission as this opportunity to be myself, which is great.

**DK** There's a term you've used in the past that really vibrates with transcendence, safety, and excess. Splurge. I'm thinking about the lushness of the grottoes you've made. Of course, with a larger, public space you don't need models and knickknacks to stand-in as residents. What, in terms of this scale, is exciting in a technical, material, or aesthetic way about this project?

**LH** What's really exciting is that folks will come off the elevator at The Met and walk out onto the rooftop and

experience the architecture, the sphinxes, and the columns. The Met is situated in Central Park, so it was important to me that the structure can be viewed from the park. The columns are taller than the pergola of the Museum roof, which is about twelve feet, so the installation will certainly be viewable from Central Park. Then, there are various sight lines and vantage points, so the images on the west exterior wall of the structure are a lot more blown out so that you can see them from a distance in the park. For the western exterior's elevation, I am reorganizing the text and signage I've been collecting in Los Angeles into a poem about self-determining our own structures and spaces. Then, once The Met exhibition has ended, I can return these signs back to their original environment in LA.

As far as the interior spaces, they are a lot denser and more layered, and I wanted them to be as maximalist as we could possibly make them, so the experience wouldn't be about you walking into the installation just to be decoding something: it would be about reading text, reading images, and holding you in the space.

In the cube, an oculus and monumental door heights at the entry points will facilitate lighting in the space, which I think will be very dramatic. The cube is a very full space, though simple in form.

DK    Something you talked about earlier in this conversation and in past dialogues is the idea of creating poetic architectural moments in the spaces you build. Where is a site in which you've experienced a poetic architectural moment? Not that you're trying to reproduce that precise feeling, but what has evoked it for you?

LH    I guess when I think about a building project, something that inspires me, and that I'm in awe of every day that I pass them, are these architectural structures that Pasacio the King—who's a community leader in the neighborhood, a sign painter, a DJ, a hairstylist, a singer; he's sort of this everything Renaissance South Central man—builds on the fly. He's in the parking lot at Home Depot, he's at the park, he's up the street. He's literally building structure out of necessity. Some of it he lives in. Some of it he paints out of. To see him constantly accumulate material in real time every day as I'm going to get coffee, as I'm leaving work, whatever, is just super inspiring for me. And then you meet him and that's a whole other portal. He just gives me the audacity to start building.

It's a constant freestyle with him. You see him cutting and editing and adding to and picking apart and painting and tearing it all down, starting over, in real time. It's fantastic. A fire marshal's nightmare.

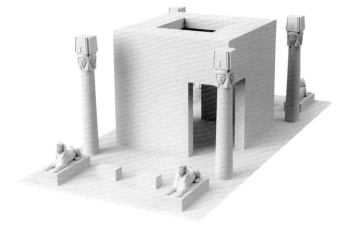

Fig. 22. Design rendering for The Met Roof Garden Commission, 2023

DK  Exactly.

LH  It's the best thing I've ever seen.

DK  That constant shifting is something I've tried to articulate about your work in the past: the distinction between a monument and a memorial. To hold something that refuses permanence, that's constantly shifting and shapeshifting—it creates monuments to these moments. And it just reinforces the idea of a durational artwork, right, because it's not necessarily climatic elements that are causing it to change, but social elements.

LH  Yeah, and for Pasacio, he's getting a million parking tickets, so he'll get a truck and rebuild a whole new architecture on the back of it, just out of the necessity to move or react. In that way, his structures become these characters in the neighborhood that show up and disappear, and it's really great.

He's just a whole other thing. I've never met anyone like him. Just watching him build and archive keeps things in line for me.

DK  Absolutely. You talked earlier about how the building materials in your neighborhood of South Central have this environmental, institutional relationship to the community based upon the fictions that the builders had of the folks who live

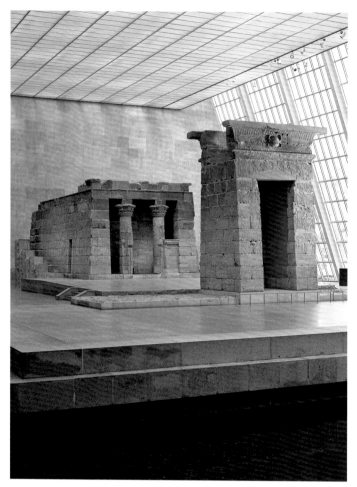

Fig. 23. The Temple of Dendur. Egypt, Roman Period, reign of Augustus Caesar, completed by 10 B.C. Aeolian sandstone, temple: H. 21 ft. (6.4 m); W. 21 ft. (6.4 m); L. 41 ft. (12.5 m); gate: H. 26 ft. 6 in. (8.1 m); W. 12 ft. (3.7 m); D. 11 ft. (3.4 m). The Metropolitan Museum of Art, New York, Given to the United States by Egypt in 1965 and awarded to The Metropolitan Museum of Art in 1967 (68.154)

there. In considering that and knowing how important location is to you, I'm recalling how in the past you've collected signs and posters from around your neighborhood and brought them into your mythical spaces. I know you're bringing signage from LA to The Met; will you be gathering objects from New York? Is this Los Angeles coming to New York? What do you wish to make present for attendees at The Met?

LH     There's the conceit of the installation returning home, to South Central Los Angeles after its presentation at The Met, so it needs to be as Western Avenue [a major Los Angeles roadway] as possible. But when I was living in Harlem during my residency at The Studio Museum in Harlem, I met folks with all sorts of ideological positions around ancient Egypt as spiritual science—that's a theology for these folks, who, through various contexts and movements, were pyramid builders. I'm super excited to re-engage with those people, many of whom were in my studio at the Studio Museum, riffing with me on my works, which remixed pharaonic architecture. My interest was never about needing to recreate pharaonic objects or anything like that. It was more figuring out how I could appropriate some of the forms, so that they appear antiquated but are actually contemporary, as a way to think about permanence in storytelling and to think about a collective Black future.

For this project, I would like to re-engage with these places where I was in conversation with folks who were, similar to my father, consumed by ancient Egypt and these fantastical, idiosyncratic origin stories as an armor and heart space to move through the world.

DK     What I really appreciate about what you just said is that mythos doesn't mean some idea that's less than reality. Do you feel that this project is the culmination of a mythos for you? Is this the beginning of a new thing or is it a continuation?

LH     I think it'll always be a continuation, but I think after this presentation, it's just time for the form to evolve. I've sampled hieroglyphs and reliefs enough, and now I'm interested in the work being not only carving, drawing, and sculptural moments with three-dimensional elements protruding from the compositions. It's beyond time to introduce color, to introduce the actual ephemera, to introduce digital processes, to introduce printmaking and new layers to the surfaces of the engravings. The material is gypsum, which is this everything surface, so we're experimenting in the studio. By nature of it being a plaster-looking stone, the work is at first missing the Day-Glo colors, the foil, and the metallics that I have used in the past. If I'm carving a guy

Fig. 24. Lintel of Amenemhat I and Deities. Egypt, Middle Kingdom, Dynasty 12, reign of Amenemhat I–Senwosret I, ca. 1981–1952 B.C. Painted limestone, 14 ½ × 68 in. (36.8 × 172.7 cm). From Lisht North, Pyramid Temple of Amenemhat I, MMA excavations, 1907. The Metropolitan Museum of Art, New York, Rogers Fund, 1908 (08.200.5)

Fig. 25. Incised Furniture Plaque with a Frieze of Lotus Blossoms and Buds. Neo-Assyrian, Mesopotamia, ca. 9th–8th century B.C. Ivory and paint traces, 1 ¼ × 6 ¾ in. (3.2 × 17.1 cm). The Metropolitan Museum of Art, New York, Harris Brisbane Dick Fund, 1967 (67.22.8)

with waves, the shadow of the waves and the waves themselves are an image. So, my next goal is trying to figure out how to layer all of these visual cues onto one surface. But it'll still be structural.

And as I'm carving the figures more and more, and as they're produced more and more in their own iterations, they'll be referencing ancient Egyptian objects less and less. I'm ready to evolve.

It'll be like if Parliament's album *Trombipulation* needed a set.

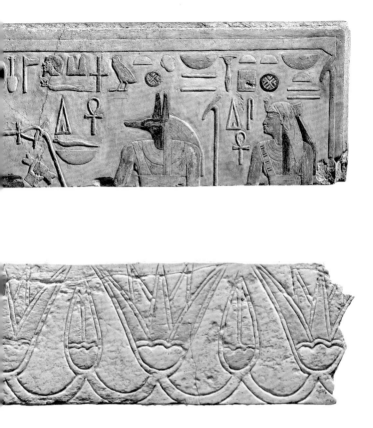

DK  Got it.

LH  Like, Parliament or whoever was doing their set design, is not going to use the pristine patina of a plaster structure. That would never happen. It would be missing its funk.

DK  Yeah.

LH  In the compositions we're creating for The Met, the funk is there. And it's in some of the juxtapositions of the images for sure. But some of the funk is still missing—the structure's too perfect now.

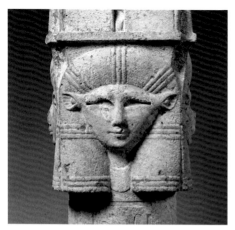

Fig. 26. Detail of Column with Hathor-Emblem Capital. Egypt, Late Period, Dynasty 30, reign of Nectanebo I, 380–362 B.C. Painted limestone, H. 40 3/16 in. (102 cm). The Metropolitan Museum of Art, New York, Gift of Edward S. Harkness, 1928 (28.9.7)

DK  Is the excess represented in some of the reliefs and drawings you're creating the way to make it less perfect?

LH  Totally. The excess that I'm interested in is about material, about color, about layers. And that's what the drawings are. But there's other materiality that I wish, as opposed to *representing* something, like for example, incense in a carving, could be superimposed onto the surface and could be taken off the wall, so it could be functional sculpture or architecture.

DK  Well, there's funk in functional. I'm reminded about one thing that's always been an interest of yours and has oftentimes been frustrating: when does an audience's experience with your work begin? How do you avoid making the experiences you create a metaphor for another experience?

I remember you once said about a past installation: "I wanted people to come up an escalator to get there." Because the ascent was the beginning. I'm thinking about how you imagine a total experience. What are some of the activities you've already planned to happen in this space once it's at The Met?

LH  In my dream world, I would invite performers, musicians, and other folks to spend time there with me. And I don't think everything should be public. But as a work installed at a public museum, it has to be, you know? That's also what has been frustrating: you make this work and then it belongs to the public. You can't have a

private moment in it to learn from it, to be in conversation with folks about it.

DK   Regarding conversations with the work, which pieces from The Met collection particularly resonate with you?

LH   We're remixing Hathor columns from ancient Egypt. These columns feature crowns with four-sided portraits of the goddess Hathor, which implied that she was able to see all sides of the earth. We're reimagining that, and instead of featuring Hathor's image, we are using portraits of folks in the neighborhood and in my family—folks I want to pay homage to, the pantheon of leaders and genius in the community. They will act as protective figures of the space.

I've been working really hard at figuring out how to replicate these columns, even down to the ornamentation. The patterns are just so beautiful, you know? I'll be substituting some of the patterns with those that I collected in South Central, which I found on surfaces or carved into spaces you're not supposed to carve into. Bathroom mirrors, bus windows.

And then as far as the works I'm inspired by at The Met, so many of the Egyptian reliefs—the markings are just so intricate and beautiful. And they hold up in the present day. That's my interest: I'm still able to see these proposed records of a pharaoh's life or afterlife and they're gorgeous.

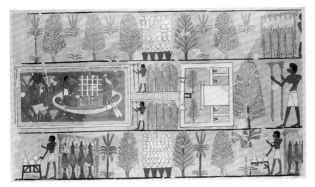

Fig. 27. **Charles K. Wilkinson.** Facsimile of Funeral Ritual in a Garden, Tomb of Minnakht. Egypt. Facsimile: A.D. 1921; original: New Kingdom, Dynasty 18, reign of Thutmose III, ca. 1479–1425 B.C. Tempera on paper, 28 1/8 × 48 1/16 in. (71.4 × 122 cm). Painted at Qurna for The Met's Egyptian Expedition, 1921. The Metropolitan Museum of Art, New York, Rogers Fund, 1930 (30.4.56)

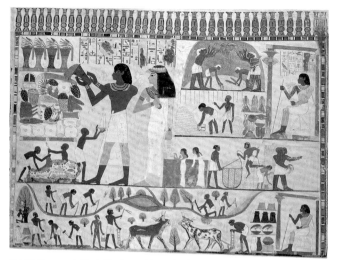

Fig. 28. **Norman de Garis Davies** and **Lancelot Crane.** Facsimile of Scene from Nakht's Offering Chapel. Egypt. Facsimile: A.D. 1908–10; original: New Kingdom, Dynasty 18, later reign of Amenhotep II–mid-reign of Amenhotep III, ca. 1410–1370 B.C. Tempera on paper, 67 ½ × 89 ¼ in. (171.5 × 226.7 cm). Painted at Qurna by the Graphic Section of The Met's Egyptian Expedition, 1907–10. The Metropolitan Museum of Art, New York, Rogers Fund, 1915 (15.5.19b)

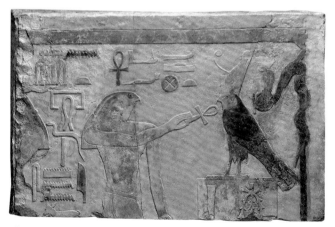

Fig. 29. Relief Block from a Building of Amenemhat I. Egypt, Middle Kingdom, reign of Amenemhat I–Senwosret I, ca. 1981–1952 B.C. Painted limestone, 24 × 38 in. (61 × 96.5 cm). From Lisht North, Pyramid Temple of Amenemhat I, MMA excavations, 1907–8. The Metropolitan Museum of Art, New York, Rogers Fund, 1908 (08.200.6)

Fig. 30. Members of Halsey's studio

DK   What else would you like in *this* record?

LH   I think it's very important that folks know this project
wasn't outsourced to a fabricator.

My studio is doing it ourselves. There's a lot of knowledge-
sharing happening within the studio, and I couldn't be prouder of the
people I'm working with. The group of engravers who carve with me.
The fabricators. The folks with an architectural background, who are
tracing and creating images from those in my archives. There's very
rigorous mold-making experimentation that's happening, and the
studio is creating architectural casts the public will actually walk on.
That's a huge next step for me.

Because until now it's been that I reference the construc-
tion material, but the final work doesn't have structural integrity. So, it
just becomes aesthetic material. But this will be the first time that it's
the real deal Holyfield, which has been great.

It's a very hands-on project. Hopefully Black builders will
be the folks who erect the structure when it arrives at The Met. We're
also working very hard to find union Black metal framers. It's not just
representationally this Black space, it's built by us as well, which I
think is important to empower folks.

*the eastside of
south central
los angeles
hieroglyph
prototype
architecture (I),
2023*

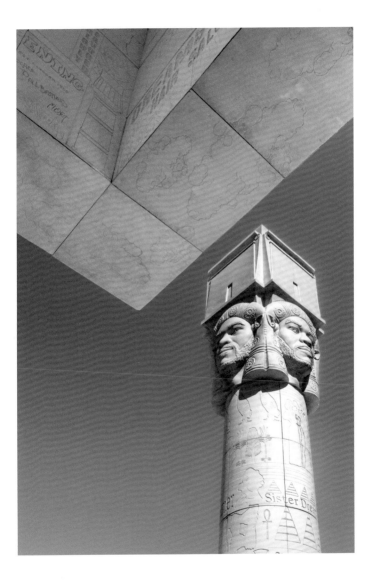

53

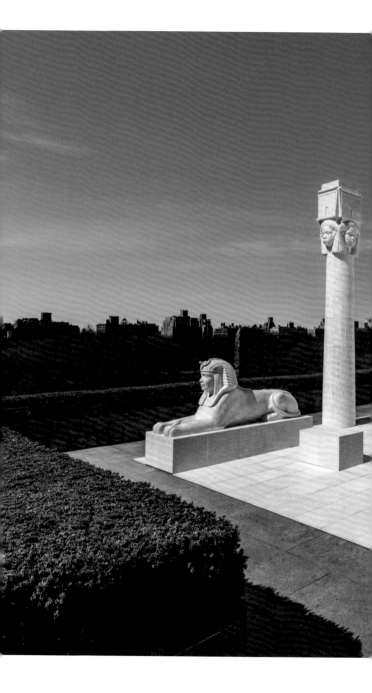

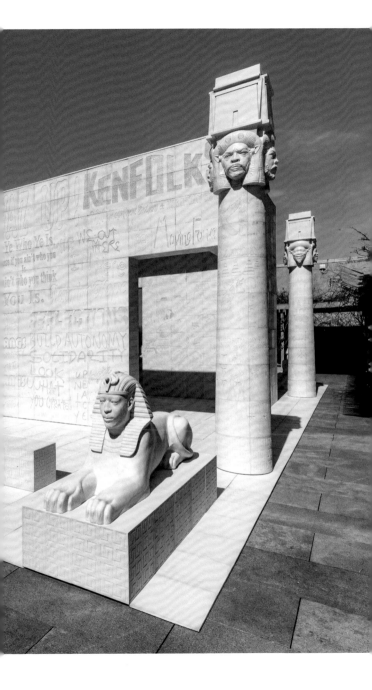

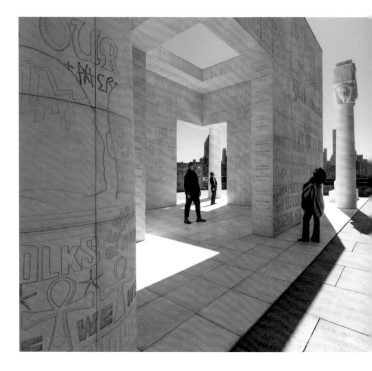

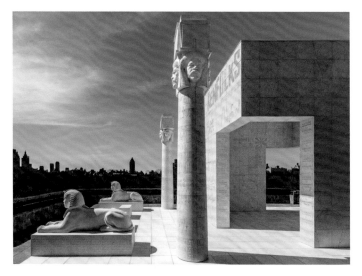

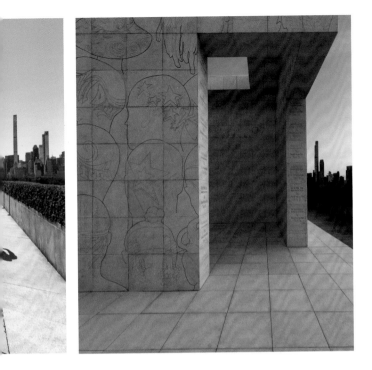

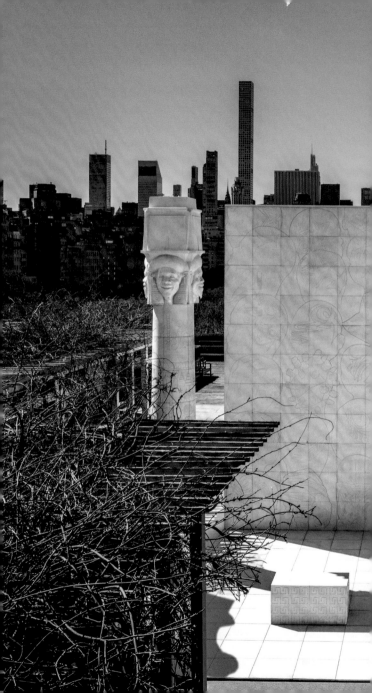

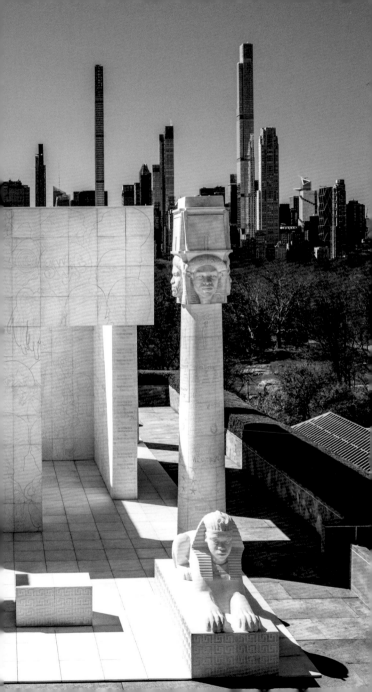

# Selected Exhibition History

# Further Reading

Alison, Jane. *Future City: Experiment and Utopia in Architecture*. New York: Thames & Hudson, 2007.

Anderson, Sean, and Mabel O. Wilson. *Reconstructions: Architecture and Blackness in America*. Exh. cat. New York: The Museum of Modern Art, 2021.

Arnold, Dieter. *Temples of the Last Pharaohs*. New York: Oxford University Press, 1999.

Blauvelt, Andrew, ed. *Hippie Modernism: The Struggle for Utopia*. Exh. cat. Minneapolis: Walker Art Center, 2015.

Bussard, Katherine A., Alison Fisher, and Greg Foster-Rice. *The City Lost & Found: Capturing New York, Chicago, and Los Angeles, 1960–1980*. Exh. cat. Princeton, N.J.: Princeton University Art Museum, 2014.

Chalk, Warren, et al. *Archigram: The Book*. Zurich: Park Books, 2018.

Cheng, Irene, Charles L. Davis, and Mabel O. Wilson eds. *Race and Modern Architecture: A Critical History from the Enlightenment to the Present*. Pittsburgh: University of Pittsburgh Press, 2020.

Cooke, Sekou. "As I Manifest: Contemporary Speculations on Hip-Hop Architectural Education and Practice." In *Hip-Hop Architecture*. London: Bloomsbury Visual Arts, 2021.

Dahinden, Justus. *Urban Structures for the Future*. London: Pall Mall Press, 1972.

Drew, Kimberly, and Jenna Wortham. *Black Futures*. New York: One World, 2020.

Ellegood, Anne, and Erin Christovale, eds. *Lauren Halsey: Mohn Award 2018*. Exh. cat. Los Angeles: Hammer Museum, University of California; DelMonico/Prestel, 2020.

Harriss, Harriet, Rory Hyde, and Roberta Marcaccio, eds. *Architects after Architecture: Alternative Pathways for Practice*. New York: Routledge, Taylor & Francis Group, 2021.

Hunt, Erica, and Dawn Lundy Martin. *Letters to the Future: Black Women / Radical Writing*. Tucson: Kore Press, 2018.

Kearney, Douglas. *Sho*. Seattle: Wave Books, 2021.

Kenner, Rob. *The Marathon Don't Stop: The Life and Times of Nipsey Hussle*. New York: Simon & Schuster, 2020.

Lawson, Len, ed. *The Future of Black: Afrofuturism, Black Comics, and Superhero Poetry*. Durham, N.C.: Blair, 2021

Lokko, Lesley. *White Papers, Black Marks: Architecture, Race, Culture*. Minneapolis: University of Minnesota Press, 2000.

Petrie, W. M. Flinders. "The Soul-House in Egypt." *Man: A Monthly Record of Anthropological Science* 7 (1907), pp. 113–14.

Phillips, J. Peter. *The Columns of Egypt*. Manchester, U.K.: Peartree Publishing, 2002.

Robins, Gay, and Ann S. Fowler. *Proportion and Style in Ancient Egyptian Art*. Austin: University of Texas Press, 1994.

Rosas, Abigail. *South Central Is Home: Race and the Power of Community Investment in Los Angeles*. Stanford, Calif.: Stanford University Press, 2019.

Sargent, Antwaun, ed. *Young, Gifted and Black: A New Generation of Artists: The Lumpkin-Boccuzzi Family Collection of Contemporary Art*. Exh. cat., OSilas Gallery at Concordia College, Bronxville, N.Y.; Lehman College Art Gallery, New York; El Paso Museum of Art; Gallery 400 at University of Illinois, Chicago; Lehigh University, Bethlehem, Pa.; Manetti Shrem Museum of Art, Davis, Calif.; University of Denver; 2019–23. New York: Distributed Art Publishers, 2020.

Scott, Allen John, and E. Richard Brown. *South-Central Los Angeles: Anatomy of an Urban Crisis*. Los Angeles: UCLA Lewis Center for Regional Policy Studies, Graduate School of Architecture and Urban Planning, 1993.

Sides, Josh. *L.A. City Limits: African American Los Angeles from the Great Depression to the Present*. Berkeley: University of California Press, 2003.

Stierli, Martino. *Las Vegas in the Rearview Mirror: The City in Theory, Photography, and Film*. Los Angeles: Getty Research Institute, 2013.

Tattersall, Lanka, and Lauren Halsey. "Lauren Halsey: The Future Is Now." *Lauren Halsey: we still here, there*. Exh. brochure. Los Angeles: The Museum of Contemporary Art, 2018.

Wilkerson, Isabel. *The Warmth of Other Suns: The Epic Story of America's Great Migration*. New York: Vintage Books, 2011.

# Photography Credits

Courtesy Carriage Trade and Denise Scott Brown: fig. 14; Digital Image © CNAC/MNAM, Dist. RMN-Grand Palais/Art Resource, NY, photo by Philippe Migeat: fig. 10; Division of Rare and Manuscript Collections, Cornell University Library: fig. 1; © Ron Herron Archive. All Rights Reserved, DACS/Artimage 2021: fig. 6; Courtesy of David Kordansky Gallery: figs. 2, 8, 12, 13, 15; Courtesy of David Kordansky Gallery, photo by Allen Chen / SLH Studio: figs. 3, 4, 18; Courtesy of David Kordansky Gallery, photo by Brian Forrest: fig. 17; Courtesy of David Kordansky Gallery, photo by Jeff McLane: fig. 16; Courtesy of David Kordansky Gallery, photo by Abraham Thomas: fig. 5, p. 6; Courtesy of David Kordansky Gallery, photo by Robert Wedemeyer: fig. 11; Courtesy of David Kordansky Gallery, photo by Joshua White: p. 4; Courtesy Lauren N Thangs Studio: figs. 22, 30; Image © The Metropolitan Museum of Art: figs. 7, 9, 19, 23, 24, 26, 26, 27, 28; Digital Image © The Museum of Modern Art/Licensed by SCALA/Art Resource, NY: fig. 20; SLH Studio: fig. 21

# Acknowledgments

First and foremost, I would like to express my deep thanks to Lauren Halsey for accepting our invitation to produce this commission and for bringing such vision and perseverance to this project. Despite the continuing challenges posed by the COVID-19 pandemic, especially those that directly impacted production within her studio, Lauren showed remarkable resolve throughout the process. It has been a pleasure working with her, and I'm also grateful for our inspiring conversations during these past two years and her generosity during my time visiting her in Los Angeles.

Lauren has an amazing group of collaborators who realized this project. I'd like to recognize the invaluable contributions of her studio team, especially Amanda McGough, alongside her key consultants Brent Mandel and Michael Zahn, and finally, her team at David Kordansky Gallery: Teresa Eggers, Kurt Mueller, Amanda Ball, Alice Chung, Camila Nichols, Julie Niemi, Emerald Woods, and David Kordansky.

At The Met, this commission would not have been possible without the support of Daniel H. Weiss, President and CEO, and Max Hollein, Marina Kellen French Director, and the vision and advocacy of Sheena Wagstaff, former Leonard A. Lauder Chair, and David Breslin, Leonard A. Lauder Curator in Charge, Department of Modern and Contemporary Art. As my partner on this installation, Sheena was not only the commissioning curator but also a vital interlocutor throughout the evolution of the project. Special recognition is due to Pari Stave, former Senior Manager, whose wise counsel and tireless efforts were indispensable in the success of this commission. Other colleagues in the Department of Modern and Contemporary Art who provided invaluable assistance include Mallory Roark, Padget Sutherland, Michaela Bubier, Jasmine Kuylenstierna Wrede, Elizabeth Doorly, and Olivia Henry-Jackson.

The organization of this project has been adeptly managed and supported by various colleagues in the Museum, including Quincy Houghton, Deputy Director for Exhibitions, Jason Kotara, Touring Exhibitions Project Manager, Katy Uravitch, in both her current role as Senior Manager, Administration, Operations, and Collection Management, Department of Modern and Contemporary Art, and former role as Senior Exhibitions Project Manager, Marci King, Associate Exhibitions Project Manager, Taylor Miller, Buildings

Manager for Exhibitions, Matthew Lytle, Assistant Buildings Manager, Mary F. Allen, Senior Associate Registrar, Meryl Cohen, Chief Registrar, Tiffany Sen, Chief Procurement Officer, and Amy Desmond Lamberti, Associate General Counsel. For their expert advice on materials and safety, I am grateful to Kendra Roth, Objects Conservator, and Deborah Gul Haffner, Environmental Health and Safety Manager. I would also like to thank my colleagues in the Department of Egyptian Art, Diana Craig Patch, Lila Acheson Wallace Curator in Charge, Niv Allon, Associate Curator, and Danielle Zwang, former Research Assistant, for their generosity and time in sharing their knowledge and valuable insights into the outstanding Egyptian art collection at The Met.

My colleagues in Development have been essential in securing the long-term sustainability and financial support that makes the Roof Garden Commissions possible, and I'd like to extend my thanks to Whitney Donhauser, Hannah Howe, Jason Herrick, Jessica M. Sewell, John L. Wielk, and our former colleagues Clyde B. Jones III and Hillary Bliss. In External Affairs, Alexandra Kozlakowski and Kenneth Weine have been instrumental in presenting Lauren Halsey's visionary project to our public audiences.

This book is the result of a collaboration with key colleagues in The Met's Publications and Editorial Department: Kayla Elam, Lauren Knighton, Josephine Rodriguez, Mark Polizzotti, Michael Sittenfeld, and Peter Antony. Gina Rossi was responsible for the beautiful design, and Erica Allen and Hyla Skopitz evocatively captured the commision for this publication. I would also like to express my gratitude to the poet, performer, and librettist Douglas Kearney for his insightful and lively interview with Lauren Halsey for this book.

Finally, my sincere thanks go to Bloomberg Philanthropies for its long-standing sponsorship of these commissions. I send my gratitude to The Daniel and Estrellita Brodsky Foundation and the Barrie A. and Deedee Wigmore Foundation for their meaningful commitments, and to Cynthia Hazen Polsky and Leon B. Polsky for their steadfast support of the Roof Garden exhibitions year after year. For their generous contributions to the project, I extend my appreciation to Vivian and Jim Zelter and Carla Emil and Rich Silverstein. The publication of this book has been made possible through the generosity of the Mary and Louis S. Myers Foundation Endowment Fund, for which I am grateful.

Abraham Thomas
Daniel Brodsky Curator of Modern Architecture, Design, and Decorative Arts
Department of Modern and Contemporary Art

The artist would like to thank:
Antoinette Grace Halsey (Byone), Aaron Miller, Alex Franco, Alistair Maskell, Allen Chen, Allison Bautista, Alma Ramos, Alyssa Tejada, Amanda McGough, Andre Hampton/Sketch, Andreina Giron, Angel Ballesteros, Angel Xotlanihua, Anthony Creeden, Atiyeh Hess, Barrington Darius, Benjamin Afflalo, Ben Carlton Turner, Ben Ruiz, Brandon Davis, Breonte Davis, Cesar Alvarado, Christopher Rendon, Colin Palmer, Connor Furr, Corbin Ham, Cree Vitti, Daniel Beckwith, Daniel Diaz, Daniel Gutierrez, Daniel Wroe, Danny Heidner, David Kordansky Gallery, Douglas Kearney, Elijah Ford, Emma Diffley, Emmanuel Carter, Esteban Sancion, Francisco Medina, Ixmal Henriquez, Jake Jones, Jasmin Juarez, Jay Lee, Jeff Lurie, Jerry Pena, Joaquin Keller, John Lemon, Jonny Park, Jose Acevedo, Josie Macias, Jynx Prado, Keenan Derby, Keylan Jaundoo-Baker, Kiara Green, Laila Carter, Laura Lucas, Lizette Hernandez, Louis Taylor, Luke Powell, Maggie Zheng, Mariner Padwa, Mark Taylor, Martina Crouch, Mauriano Topete, Maximilian Nickou, Monique McWilliams, Nick Barton, Nick Rodrigues, Nico Young, Ofelia Marquez Stephens, Olivia Jean, Ozzy, Paolo Iarussi, Patrick Winfield Vogel, Ricky, Rod Fahmian, Ryan Crudington, Stephen Kingsberry, Sabino, Sunny, Sydney Busic, Tomas Dias, Vetho Cato, Vincent Alvarez, Virginia Swenson, Von Curtis, West Adler, Zac Thomas

This catalogue is published in conjunction with *The Roof Garden Commission: Lauren Halsey*, on view at The Metropolitan Museum of Art, New York, from April 18 through October 22, 2023.

The exhibition is supported by

**Bloomberg Philanthropies**

Additional support is provided by The Daniel and Estrellita Brodsky Foundation, the Barrie A. and Deedee Wigmore Foundation, Cynthia Hazen Polsky and Leon B. Polsky, and Vivian and Jim Zelter.

The catalogue is made possible by the Mary and Louis S. Myers Foundation Endowment Fund.

**Published by The Metropolitan Museum of Art, New York**

Mark Polizzotti, Publisher and Editor in Chief

Peter Antony, Associate Publisher for Production

Michael Sittenfeld, Associate Publisher for Editorial

Edited by Kayla Elam

Designed by Gina Rossi

Production by Lauren Knighton

Image acquisitions and permissions by Josephine Rodriguez

Photographs of works in The Met collection are by the Imaging Department, The Metropolitan Museum of Art, unless otherwise noted.

Additional photography credits appear on page 62.

Typeset in Galaxie Polaris and Chronicle

Printed on Endurance Silk 100lb

Separations by Professional Graphics, Inc., Rockford, Illinois

Printed and bound by GHP Media, Inc., West Haven, Connecticut

Front and back covers and pp. 1, 8, 53–59: The Roof Garden Commission, 2023. Photography by Hyla Skopitz

Page 2: Lauren Halsey. Courtesy of David Kordansky Gallery, photography by Russell Hamilton

The Metropolitan Museum of Art
1000 Fifth Avenue
New York, New York 10028
metmuseum.org

Distributed by
Yale University Press,
New Haven and London
yalebooks.com/art
yalebooks.co.uk

Cataloguing-in-Publication Data is available from the Library of Congress.
ISBN 978-1-58839-749-2